WITH THE CURRENT

A meditative tribute
to 18 Harmonizing Movements Qigong

Poetry by Susan Deborah King

Photography by Sue Kearns

With thanks to

Mark Nunberg,

and to Steve and Autumn Compton,

our qigong instructors

January 1, 2023
Minneapolis, Minnesota

Introduction

We undertake these movements to rouse within ourselves the power of living elements. We choose to be in sync with waves and birds and flowers, with clouds, mountains and the wind, to align with setting and rising, growth and decay. We want our bones to hum with the spinning of orbs, to awaken to the beauty of mud, the horror of hate, to stand in the river of our thoughts and feel the current, and so, we step away from the race, from screens, from acquiring and practice slowly, gently, consciously – smilingly these forms.

WAVING HANDS BY THE LAKE

Waving Hands by the Lake

We are paying homage to water, of which we are mostly made,
greeting it with gladness for its beauty how it cleanses, slakes, relieves.
We pay obeisance to its eminence, for without it we would not be.
How the wind ripples its surface with changing-every-second
designs, writes in cryptic script across it poems whose drift
we would catch with the unfurled sails of our minds, but once
imprinted, in a flash – erased. Might we be as quickened to our
moments primed equally for constancy, adventure, revolt, demise?

OPENING AT THE TOP OF THE MOUNTAIN

Opening at the Top of the Mountain

Here I am. Not hiding – and – further – I'm OPEN! I spread my arms
to embrace sky and cloud, the rocks under my feet, the stars, their fire,
the distant sea. But can I accept, while putting my shoulder to the wheel
for change, the squalid barrios and those in them suffocating, the haze
we've made, its filthy lid, the makeshift gallows? Can I take all this
to heart as well as these snow-draped peaks, the firs, the wildflowers
quivering in the breeze? I will keep practicing, keep practicing
with sincere intent to open the window of myself to ALL the world.

SWINGING THE RAINBOW

Swinging the Rainbow

In celebration, we take all colors into our arms. This is not
as easy as it seems: to accept within ourselves – fine – the pink,
the green – the peony, the sward, the bluebird, but to embrace the
gray, the brown, the shameful grime, and not scapegoat them
upon the underserving: this is hard. Within the circle we form,
we aim to encompass the whole spectrum, rocking it side to side
to lullaby, for our growth, our wholeness, the hues to which
we are averse, the tones we curse and thrust away from us.

PARTING THE CLOUDS

Parting the Clouds

Do I want them to part, really? Isn't it more comfortable
to stay muffled and diffuse, hidden, fuzzy? No decisions
to be made. No actions to take. On the other hand, it's hard
to breathe. It's gloomy! If I pull them off like cotton gauze,
a way might open; healing might happen. I could set forth.
But then, the searing blue will confront me with its terrifying
blankness to write upon with the course of my time on earth.
Curtains open, on stage, audience waiting. Only script, improv.

FLOATING SILK ON AIR

Floating Silk on Air

Let the air take these gossamer strands. Can I keep them aloft? I don't know how long I can sustain engagement with such delicacy. Creatures extruding from themselves these glimmering fibers produce from them cocoons in which to wrap themselves for transformation. In order to change, to develop wings, to become something wholly other, they must go quiescent for a stage. This is what it takes. If we want to achieve, to grow, extend our reach, we who hurry, can we slow, can we undertake a period of repose?

ROWING ACROSS THE BIG LAKE

Rowing Across the Big Lake

It's a long journey. How can I undertake it? Do I have strength?
Do I have the stamina to get to the other side? Oh my! One stroke
at a time and slowly, slowly. So I can feel the pull of my oars in water,
my muscles working, moving me forward. So I can hear the plashing
when I lift the oars for another tug and breathe in the sunlight, watch
it jittering over the surface, the energy of it, the frolicsome dance.
Whatever I thought was so important, what I was so impatient to get to
fades as I put myself simply into the movement, into this place, this day.

RAISING THE SUN

Raising the Sun

When you're ready. When you can no longer bear things to be hidden. When you think you're strong enough for the whole truth to come, at last, to light, bring it up. Yes, out of the night, out of the abyss within, over the lip of the world. That's it. Gently, lift it. Revel in the colors, the plum, the cerise, searing the edge as it rises. Behold the leonine corona roaring above the globe. Let it shine on whatever is, so that all can be seen: blinding beauty, ruin, waste, the trash, the trauma, bends of rivers, blooming, bongos, scenes of dreams, the birds and barracudas, wounded children, the trees.

GAZING AT THE MOON

Gazing at the Moon

We can't help but do it, so bright and beguiling is its face, full or profile,
coyly hid from us, merely peeking, fully exposed. Center of the night and
its relief, its priceless pearl, it changes as we do, our energies and moods.
Placing no emphasis on any one phase, it could train us to respect the dark,
the partial, the awkwardly shaped. What if the sky is too crowded with towers,
tainted by light we humans have made? All the more to seek it out, to track it,
to look up to it as we would to a muse to teach us its changes, its aspects:
no stage holds, but we become luminous pouring ourselves wholly into each.

WIND RUSTLES LOTUS LEAVES

Wind Rustles Lotus Leaves

Is it a kind of affection bestowed by one of the elements, the wind
tousling the leaves as one would curls on the head of a beloved child?
Or, like a child, wanting to see something move that has been still?
An impatient nudging for the plant to flower? Or an appreciation of their
shape, those broad green, deeply veined, crenellated leaves that act as
platters serving up what has been deemed the quintessence of flower –
the quintessence period: petal by pink-tinged petal opening to an aureole,
whose center bristles with gold, glowing from an unknown source within.

WAVING HANDS LIKE CLOUDS

Waving Hands like Clouds

They float over us. Guardians? Snoops? Cargo carriers loaded for storm, with which they will visit us as nourishment, disturbance. Swabs, swathes assuaging the blue, tempering it, they change and move, always moving, making shapes, plumping, flattening, shredding, stretching. A wisp will detach from a larger poof, thin out – vamoose. Under them the ground is a kind of canvas upon which they cast cooling shadows, protean patterns, practicing a vanishing art. To be their like? We'd have to give up being set. We'd have to constantly re-form. Stay light and loose, light and loose.

SCOOPING THE OCEAN TO LOOK AT THE SKY

Scooping the Ocean to Look at the Sky

Never lose sight of the heavens, nor retreat from awe of them,
their immeasurable vastness downsizes us from what we're tempted
to believe. Shower yourself awake. Look up and behold what
we ourselves could never make: darkness – oblivion charged
with infinite sparks. Baptize yourself with reverence. Cover yourself
with salt. Are you worried about where you will end up? Do you think
humans are the max? As the feeling of your significance shrinks,
your spirit expands. It extends beyond your limits, so far beyond.

PUSHING WAVES

Pushing Waves

So we'll know neither crest nor trough lasts for long, we mimic the fall and rise, the rhythm, the reprise. How we fear getting stuck at the bottom, how we want at the top to hold tight, when it's just constant flux that could lull us, if we let it, could rock the worry from our minds. Think how calming it is just to watch the water, the way it flutters and spangles under the sun, how soothed we were to slosh within our mothers. It's all fine: every step on the ascent, all points on the decline. In nature, no straight lines: sound, light, rivers, land forms, clouds, flowers, even tree trunks, birds in flight.

DOVE SPREADS ITS WINGS

Dove Spreads its Wings

Are you ready to fly? To open out, apply effort and be carried by the air? The ground can feel safer, but is it? Quakes, predators, floods, storms, fires, vehicles. Lift off from that to which you cling, to which you've grown accustomed, habits that might harm you or others, rigid ideas, paralyzing fears. Feel the currents hold you up and flutter your feathers; hear through them the music wind can compose. You will land somewhere else, a vantage from which to view more clearly where you've been and assess where next. That new branch can feel good in your grasp, can feel, for a moment, like peace.

DRAGON EMERGES FROM THE SEA

Dragon Emerges from the Sea

When it rises up before us clawed, scaly, winged, reptilian, breathing fire,
is not our first instinct to recoil, to quail and turn tail? How is it this writhing,
fearsome creature brings good luck, is imbued with power, dignity, fortune,
fecundity? Wouldn't such a monster bring just the opposite: terror, mayhem,
destruction, death? Of course, it can. But what if we face whatever would
make us run when it emerges from oceanic depths to threaten us? Standing
 our ground
before it, beholding, without flinching, its horrid magnificence, we connect
ourselves most electrically with the life force; we shine brightly with being.

FLYING WILD GEESE

Flying Wild Geese

Don't they make a spectacular vector against the blue, their cries flung bold against gathering clouds, the coming dark? With instinct as compass they know where they are going: to places they can thrive. We call this "wild," and, civilized, forswear it for ourselves. We've developed instruments to tell us where to go, what to do and when. We've learned not to trust inner promptings as they might lead us astray from manufactured norms, off base, out in left field. And it's hard work, but easier, it seems, in concert with a tribe of a more primitive persuasion, compeers soaring over the globe, its curve, to a place hospitable to our souls.

WINDMILL TURNING IN THE BREEZE

Windmill Turning in the Breeze

Where we come from, where we go, no one knows. We blow through the world like a breeze caressing all that crosses or stands in our path, feeling briefly (we can never clasp) the shapes and textures of leaves, of grasses, rippling the water's skin, running our fingers through fields, stroking the cheeks of those beloved. But, too, we come up against obstacles, that, no matter hard we push, will not move, and so we proceed bruised, diverted to part the air with our presence, creating a stir, however mild. Science cannot explain the wind, why its whim, its whither or when. Let the mystery of it animate our turn and set our hearts awhirl.

WALKING ON CLOUDS

Walking on Clouds

Stepping lightly, allowing our hands gracefully, slowly to rise and descend, we do not fall through. We respect the nature of this ground, what we walk on is wispy, ephemeral, but can feel buoyant, if we do not balk, if we do not put our foot down. That way we keep what might weigh on us from landing hard on our backs and making us tumble. Tiptoeing, as in stealth, while balanced, we creep up upon ourselves as children on a playground bouncing a red rubber ball the size of a melon, the hours doing this that kept our hearts aloft. Where has that gone? That delight in pure fancy? Keep bouncing. Keep stepping.

GATHERING THE FRAGRANCE OF THE EARTH

Gathering the Fragrance of the Earth

It's Spring! Don't I want, before they fade, to gather all the blossoms I can
in my basket and take them home to feast on? How their smell, their shapes, their
colors excite me! And then there's the rich odor of tree bark after rain,
sunlight on river water, grass new-mown, earth itself softening for growth.
But how can I keep all this to myself? Let me share this bounty with *all*. Let me
spread it around, especially to those I would disdain, especially where
there is grief and pain, and, naturally, to those I love. Let the blessing of this
beauty, so intense, descend on those souls to crowd out hurt, the intention to harm.

THE MOVEMENTS

1. Waving Hands by the Lake

2. Opening at the Top of the Mountain

3. Swinging the Rainbow

4. Parting the Clouds

5. Floating Silk on Air

6. Rowing Across the Big Lake

7. Raising the Sun

8. Gazing at the Moon

9. Wind Rustles Lotus Leaves

10. Waving Hands Like Clouds

11. Scooping the Ocean to Look at the Sky

12. Pushing Waves

13. Dove Spreads its Wings

14. Dragon Emerges from the Sea

15. Flying Wild Geese

16. Windmill Turning in the Breeze

17. Walking on Clouds

18. Gathering the Fragrance of the Earth

Thanks to Libby Frost

The movements are modeled by Libby Frost. Libby has been part of the qigong group at Common Ground Meditation Center for a number of years and is also a student at Twin Cities T'ai Chi Ch'uan.

Qigong

Master Lin Housheng introduced 18 Movements (Shibashi) Qigong in China in 1979. The practice has since spread throughout Asia and beyond. Franz Moeckl brought Shibashi to Common Ground Meditation Center in Minneapolis, where guiding teacher Mark Nunberg initiated a weekly Shibashi Qigong practice group.

Susan Deborah King, MDiv

Susan Deborah King, MDiv, is the author of six volumes of poetry including, *Bog Orchids, Moondance, One-Breasted Woman* and *Coven,* and editor of two of poetry: *Out of the Depths: Poetry of Poverty, Courage and Resilience* and *Fresh Testaments*. She has taught Creative Writing and lead retreats on Creativity and Spirituality in many institutions and settings. She was a grateful member of the Common Ground qigong group for nine years until she moved from Minneapolis to Maine, where, in the summer, she writes, gardens, and enjoys being part of an intense, intimate, and beautiful island community.

Author photo by Jim Gertmenian

Sue McCormick Kearns

Sue Kearns lives in Minneapolis with husband and qigong leader, Steve Compton. They began practicing qigong together at Common Ground Meditation Center over 20 years ago. After teaching school and raising a family, Sue began working in sports photography. She says if you had a button sporting your child's soccer picture some 30 years ago, she may have taken it. Presently she volunteers her photographic skills to a women's organization, creating a directory of over 300 member portraits, and documenting weekly meetings. She always has camera (or iPhone) in hand for shooting family and friends' events.

Editing and graphic design by Jane Hufford Downes
janehufforddownespoetry.com

The Qi Gang at Matthews Park